Yixing Pottery

The World of
Chinese Tea Culture

Chunfang Pan

LONG RIVER PRESS
San Francisco

Editorial Committee

Art Adviser: Yang Xin, Wang Qingzheng & Zhang Daoyi
Chief Editor: Wu Shiyu
Deputy Chief Editor: Ma Ronghua & Dai Dingjiu
Editorial Committee Members: Qian Gonglin, Lin Lanying, Zhang Debao &
Wu Shaohua

Author: Pan Chunfang
Executive Editor: Dai Dingjiu
Designer: Lu Quangen
Introduction: Xu Chengquan
Translator: Ding Shaohong & Li Shanshan
English Editor: Luo Dayou
Series Editor: Chris Robyn

ISBN 1-59265-018-X

Library of Congress Cataloging-in-Publication Data

Pan, Chunfang.
[Yixing zi sha. English]
Yixing pottery : the world of Chinese tea culture / by
Chunfang Pan.— 1st ed.
 p. cm.
ISBN 1-59265-018-X (hardcover)
1. Yixing ware. 2. Ceramic teapots—China. 3. Potters—China. I. Title.
NK4367.I35.P3513 2004
738.3'0951'136—dc22

2004000388

Published in the United States of America by
Long River Press
3450 3rd St., #4B, San Francisco, CA 94124
www.longriverpress.com
in association with Shanghai People's Fine Arts Publishing House

Printed in China

10 9 8 7 6 5 4 3 2 1

Table of Contents

\mathcal{Y}ixing pottery, also known as *zisha* (purple clay) is a unique traditional Chinese ceramic art. It represents a type of ceramic ware with characteristics of both pottery and porcelain. Generally, the inside and outside surface of Yixing ware exhibits a natural texture, displaying the color and luster of refined pottery without any added glaze. Yixing ware includes the tea set, bottle, tripod caldron, flower pot, artistic and scholarly accessories, and sculpture. However, the tea set remains the principal category and has accounted for most of Yixing ware ' s notoriety.

With respect to the origins of Yixing ware, a legendary folk tale was recorded in the *Collection of Famous Ceramics* published during the Qing Dynasty (1644-1911): Once a strange monk roamed to Dingshu, Yixing, where he hollered to passers-by: "Riches and honor for sale!" The villagers, however, all sneered at him, and no one paid him any attention. So the monk changed his cry, "Nobody wants to buy honor, but how about riches?" The villagers were now interested and the monk led them to a spot outside the village. There the villagers found marvelous, multicolored clay rich in iron. They used the clay to make pottery ware which became world-renowned, and a never-ending source of wealth for them.

Approximately five to six thousand years ago, there emerged ceramic activities in Yixing. In Western Zhou, during the Spring and Autumn and the Warring States Periods (c. 11th century B.C.-A.D. 222), Yixing became one of the main production areas of celadon and pottery in the south. In the Eastern Han, Western Han, Eastern Jin, Song, Qi, Liang, and Chen dynasties (c. 25-618), Yixing became one of the important producing areas of warm glaze and celadon. In the Tang, Late Liang, Late Tang, Late Jin, Late Han and Late Zhou dynasties (c. 618-960), Yixing teemed with celadon. At present, numerous kiln sites of that period have been found. In the Song, Yuan, and early Ming dynasties (c. 960-15th century), the elevation of Yixing ware to daily use status experienced its first major phase of develop-

ment.

We can find descriptions about purple clay ware in documents contained in the history of the Northern Song Dynasty (960-1127). The examples include the following passages: "The cold fountain has a taste of morning, while the purple clay brings the tincture of spring." (*Wan Lin Ji* by Mei Raochen, Volume 15); "You have tea happily with a *zisha* tea set and compose poems together. I really admire your freedom and emotion." (*Having Tea and Composing Poems Together with Mei Gongyi*, by Ou Yangxiu). Cai Sizhan of the Ming Dynasty wrote, "I bought a *zisha* pot in Baixia (today's Nanjing) with five characters inscribed on it: 'Having tea and keeping detached.'"

1. Yixing Pottery: Origin and Development

*I*n late 1976, a site of Dragon kiln-producing unglazed sandy soil ware was found at the site of the newly-built tunnel kiln at the Yixing Red Flag Ceramics Manufacturing. Products found included pots, jars, water vessels, pot bodies, handles and lids, including many with kneaded dragon-head decorations. The kneading technique was identical to that on the dragon and tiger bottles prevailing in the south of the Yangtze River during the Song Dynasty (960-1279).

There were three categories for the excavated pots: the high-neck pot, the low-neck pot, and the pot with an upper handle. The clay quality was rough and aubergine in color. Furthermore, the density of the surface was poor. However, the execution of forms and lines, and the characteristic rhombic figures at the base of the spout would later influence *zisha* ware.

Before the Tang Dynasty (618-907), there was no specifically-developed ceremonial tea set. The articles used for having tea were ordinary items also used for having meals. During the Tang, the method of sipping and tasting tea paved the way for an entire array of tea-related accessories, elevating tea to the highest levels of culture and refinement. Detailed descriptions exist of as many as twenty-eight separate types of tea accessories, such as the water-boiling wind stove, tea-boiling appliances, tea-baking appliances, tea-grinding appliances, tea-measuring appliances, water-containers, salt containers, tea-drinking appliances, cleaning appliances, display appliances, etc. which together formed a highly elaborate system.

The tea set of the Song Dynasty inherited the system established in the Tang Dynasty. However, the style of Song tea sets was more magnificent compared with the comparatively simple Tang tea sets. In the Song Dynasty, utensils made of metals like gold and silver also prevailed among the nobility. In order to keep up with the fashion of tea ceremonies popular among the gentry class, accessories such as the teapot scouring brush was invented to stir the tea leaves, enhancing their flavor and the overall experience. By the time of the late Ming-

The types of excavated *zisha* teapots

Unearthed in Yang-jiaoshan in North-ern Song Dynasty	Unearthed in Dantu in Southern Song Dynasty	Unearthed in Nanjing in Jiaqing reign of Ming Dynasty	Dabin teapots unearthed in Wanli reign of Ming Dynasty

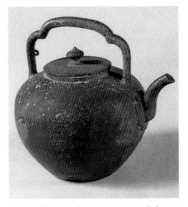 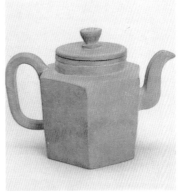

Left: Purple clay teapot with lid, excavated from the grave of Wujing at Youfangqiao outside of Zhonghuamen in Nanjing during the reign of Ming Emperor Jiajing.
Right: Hexagonal teapot made by Shi Dabin, excavated in Jiangdu.

Purple clay teapot made by Shi Dabin, excavated from the grave of Lu family in Jinpu, Fujian.

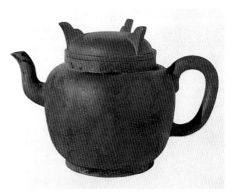

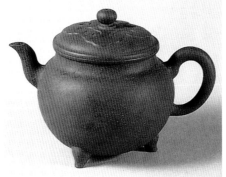

Good-luck teapot made by Shi Dabin, excavated from the grave of Hua family in Wuxi.

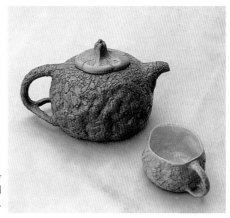

Gongchun-style purple clay Gall Teapot with the lid made by Huang Yulin.

early Qing dynasty in the mid 17th century, a trend toward simplicity was pursued again in terms of ceramic tea ware, but only because the ceremonies and rituals associated with the tea ceremony at the height of the Tang had by now fallen out of flavor. The movement toward simplicity was reflected in the method of tea preparation. In the Ming Dynasty (1368-1644), the process was no longer as elaborate as grinding leaves, adding incense, and rolling the leaves into a ball. What became popular was simply bud-tea, very similar to the commercially produced, fried green tea leaves available today. The move toward simplicity also lead to the decline of teapots made with previous metals, once common among the nobility. As a result Yixing ware became increasingly popular. The reason for such popularity of Yixing teapots coincided with the move toward a simple, aesthetically pleasing way of enjoying tea: Yixing ware was unglazed and uncolored, and consequently it could best capture the real color and fragrance of tea, and this feature echoed the aesthetic affections of scholars at that time.

2. The Monk from Jinsha Temple and the "Gongchun" Teapot

*T*he earliest known monograph specifically discussing Yixing ware in detail is *Collection of Famous Zisha Ware in Yangmu* written during the Ming Dynasty. It is there recorded that Yixing *zisha* ware crafted during the Zhengde reign of Ming Dynasty, which was in the early 16th century. It was said that a monk at the Jinsha Temple apprenticed with a potter. The monk acquired some clay from the potter, added water, kneaded it into a rough cast, hollowed the inner redundant clay, and crafted a spout, a handle, and a lid. At last a teapot was finished. After being fired in the kiln, the teapot could be used. Although the monk's name was not given, in later years it is said his skills were passed down to a boy servant. The servant, named Gongchun, himself became one of the founders of teapot art. Gongchun invented many teapots styles such as "dragon egg", "square seal", etc., but only one style, called the "gall teapot" has survived until today. The name was given because the surface of this teapot was unsmooth, with many bumps and pits like the surface of a decaying tree. The spout and handle were naturally extended, and there were fine lines resembling wood grains all over the surface. On the inner surface of the side handle were two seal characters of "Gong Chun."

From the Jiajing to the Longqing period of the Ming Dynasty (1522-1572), there were four famous teapot artists who followed Gongchun. They were: Dong Han, Zhao Liang, Shi Peng and Yuan Xi.

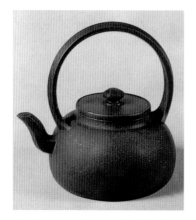

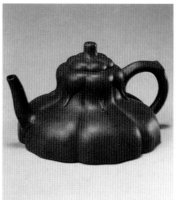

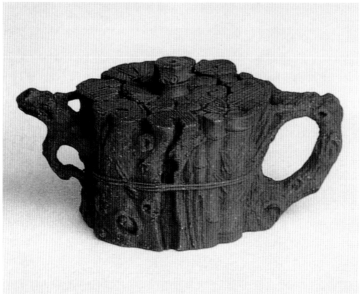

Top left: Purple clay teapot with an upper handle made by Shi Dabin (Nanjing Museum collection).

Top right: Magnolia-shape teapot made by Shi Dabin.

Bottom: Firewood Bundle Friendship Teapot made by Chen Mingyuan.

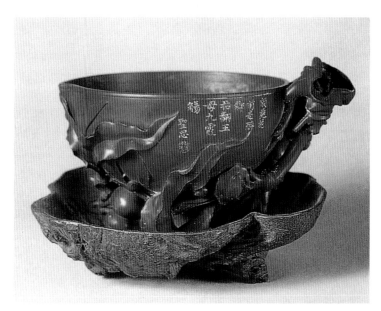

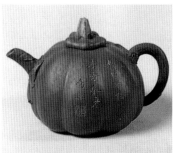

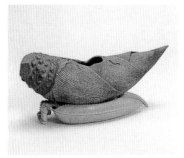

Top: Peach-shape cup made by Xiang Shensi.
Bottom left: Pumpkin Teapot made by Chen Mingyuan.
Bottom right: Bamboo Shoot Water Container made by Chen Mingyuan.

3. Yixing Ware During the Ming and Qing Dynasties

*T*he Ming and Qing dynasties were the most prosperous periods of the development of *zisha* ware. This era can be easily divided into the early phase, middle phase, and late phase.

The early phase spans the early 16th century to the early 17th century (during the reign of Ming Emperor Zhengde to Emperor Wanli). In this phase, the shape of *zisha* teapots had attracted many characteristics from copper and other metal ware, as well as influences from Ming-era furniture. *Zisha* teapots common to the early phase usually presented simple and vigorous styles and pieces shared a harmonious scale in terms of size, but the clay grains were coarse in execution. The "plain and elegant" style was the underlying pursuit of teapot artists led by Shi Dabin at that time. Usually the inscriptions were engraved in regular scripts on the teapot bottom, which was also the earliest inscription style common to modern *zisha* ware.

The middle phase is from the early 17th century to the middle 18th century (from the end of the Ming Dynasty to the reign of Emperor Qianlong of the Qing Dynasty). *Zisha* teapot art reached its zenith at that time. Famous teapot artisans came forth in great number, many fantastic styles of teapots emerged; and the teapots were not only offered as tribute to the emperor, but also sold to merchants abroad. Since the early Qing Dynasty, the seal of the craftsman who made the pot was engraved on the pot bottom or on the inside of the lid. Some artisans even made inscriptions of a poem and name seal together with the year when the pot was made.

The late phase merely serves as a continuation of the second phase, from the ending of the 18th century to the beginning of the 20th century (from the middle Qing Dynasty to the Republican Revolution). Throughout this era, the art of *zisha* teapots continued to be innovative in style and decoration, due to the participation of the literati class. Fundamentally, the teapots demonstrated a strong sense of Chinese culture and identity.

4. Famous Teapot Artists

*T*he most famous teapot artists during the Wanli period of the Ming Dynasty (1573-1619) were Shi Dabin, Li Zhongfang and Xu Youquan. Shi was the master and Li and Xu his apprentices. Shi Dabin had not only inherited the skills left by the previous generation, but also made great contributions in the improvement of many instruments associated with teapot manufacturing. He improved the techniques to moisten clay, and firing, etc. It was Shi who developed the process of *zisha* ware into an independent production system. For instance, because the preparation of clay was often the responsibility of different persons, the color was uneven due to different preparation methods used by each craftsman. Shi introduced the method of firing pieces together in a large vat, and by doing so Shi could produce *zisha* pieces with uniform characteristics.

Shi Dabin was one of the famous teapot artists. His early works were done in the style of Gongchun. Later, Shi was held in high esteem by the literati class and produced *zisha* pieces for decades. Teapots in the shape of anise, plum blossom, hexagon, shaman cap, and hoop handle were all invented by Shi Dabin.

During this period of prosperity, many famous craftsmen came forth in great number, and with them they brought many new styles of teapots. Moreover, the creation of teapots into shapes resembling real, often organic objects reached its height. The work of Chen Mingyuan was one of the finest examples of this period. The pumpkin teapot, firewood bundle friendship teapot, and bamboo shoot water container among his works all presented his ingenious ideation and extraordinary craftsmanship. Another master potter was Xiang Shengsi, who was renowned both at home and abroad for his "big peach cup." This cup was exquisitely carved, its blossom, fruit, leaves and limbs were arranged to imitate a real peach in every detail.

In the late Ming Dynasty, Hui Mengchen was another master after Shi Dabin. Hui was renowned for the making of tea sets. Hui's pots were smaller in size (usually between 80-200cc), and used for

14

Top left: Purple clay lotus-seed teapot with flat lid made by Hui Mengchen.
Top right: Hexagonal teapot with round body made by Hui Mengchen.
Bottom: Stonepot Teapot made by Chen Mansheng.

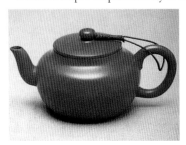
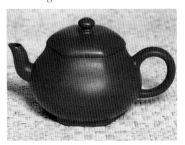
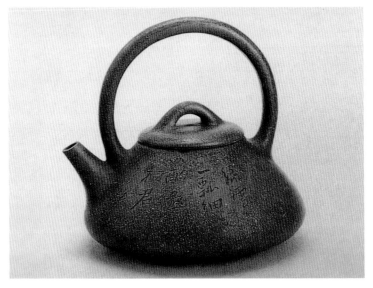

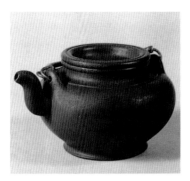 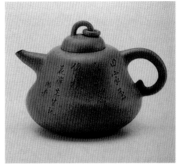

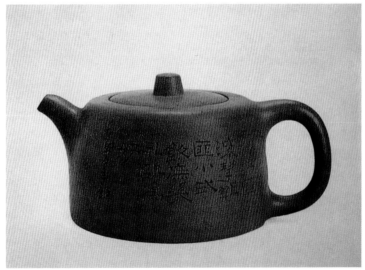

Top left: Small-egg teapot made by Shao Daheng.
Top right: Purple clay teapot in calabash shape made by Chen Mansheng.
Bottom: Hexagonal purple clay teapot in well-railing shape made
by Chen Mansheng.

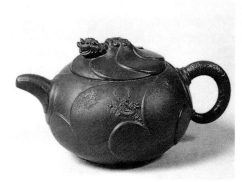

Fish-changing-into-dragon
Teapot made by Shao
Daheng.

steeping Oolong tea which prevailing in the coastal areas of Fujian and Guangdong provinces. The teapots made by Hui Mengchen were both ingeniously designed and vigorously executed, such as "Lotus seed teapot" and the "Hexagonal teapot with round body." The inscription on the bottom, "Made by Hui Mengchen in Jinxi," was one of the most famous at that time.

Starting from the middle of the Qing Dynasty, there were new changes in the shape and decoration of *zisha* ware due to the vigorous participation of China's literati, or scholar class. Since the Song Dynasty and the formal establishment of the civil service system, many highly-educated scholars and writers emerged at various bureaucratic levels of government. There was a strong cultural element to those belonging to this social class, namely, a cultivation of music, drama, and literature, Chinese chess, calligraphy, and painting. Scholars and writers displayed their work in their studios, and studied and admired the work of others. The Four Treasures of the Chinese study came to be known as the essential accessories for the serious scholar, namely, the writing brush, ink stick, ink slab and paper, were prominently displayed and fawned over. All such objects were elaborate and many were of great historical significance. An ongoing cultivation of one's mind and artistic skill became the preferred pursuit of the scholar

class.

Naturally, enjoying tea while discussing art or literature was one of the principal activities among a gathering of literati, and it was not long before their aesthetic appreciation came to be focused on zisha ware. During the Jiaqing and Daoguang reigns of the Qing Dynasty (1796-1850), a group of literati led by Jinshi-style calligraphist, Chen Mansheng, developed a new style of teapot that integrated the arts of poetry, painting, calligraphy, and seal carving. The goal was to in effect, lift the teapot to the status shared by the more traditional Four Treasures.

Shao Daheng was a teapot craftsman as famous as Yang Pengnian. Shao excelled at both imitation and innovation. His work had a plain yet elegant style, and the carvings executed were vivid and true. Among Shao's designs were the "Fish-changing-into-dragon teapot," and the "Small egg teapot."

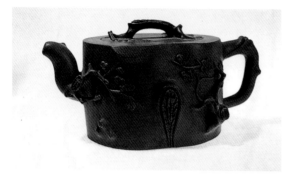

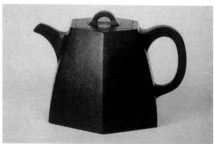

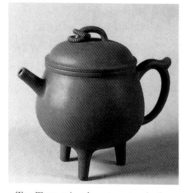

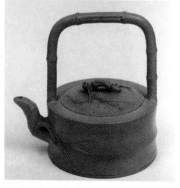

Top: Teapot in plum-tree trunk shape made by Yang family.
Middle: Hexagonal teapot in copper hammer shape made by Wang Yinchun.
Bottom left: Double-circle tripod shape teapot made by Pei Shiming.
Bottom right: Teapot in bamboo shape made by Wu Yungen.

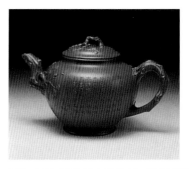
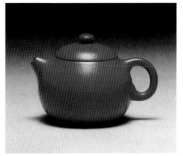
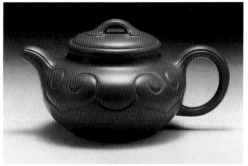
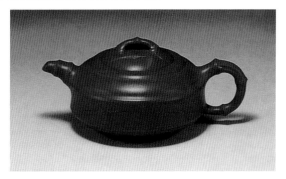

Top left: Longevity teapot made by Zhu Kexin.
Top right: Beauty of Xishi (a famous young lady) teapot made by Wang Yinchun.
Middle: Teapot of Auspicious Clouds made by Gu Jingzhou.
Bottom: Two-color bamboo shape teapot made by Zhu Kexin.

5. *Zisha* Ceramics at Home and Abroad: Prosperity and Decline

\mathcal{Y}ixing *zisha* teapots are characterized by their many diverse shapes, their meticulous, excellent craftsmanship, elegant decoration, and their integration of art with utility. These factors have made Yixing ware the apotheosis of traditional Chinese teapots. Yixing *zisha* teapots soon gained favor abroad, earning praise and recognition among European aristocracy, where the fascination with "Chinoiserie" remained a highly popular pursuit. Yixing ware was introduced to Europe as early as 1635, and with the China tea trade, it soon attained the status as the most highly desired tea set in Europe.

In Japan, the Yixing *zisha* tea set is cherished even more. The introduction of the Chinese tea ceremony of the Song promoted the widespread influence of tea culture in Japan, where it was elevated to an even higher, almost spiritual level. In 1878, two Yixing potters, Jin Shiheng and Wu Agen, traveled to Japan to impart the techniques of ceramics while helping to cultivate future Japanese potters in the Yixing style.

Modern *zisha* ware has experienced a history ranging from prosperity to decline, and back to a revival that would lead to the highest period of cultural splendor. The years 1911 to 1937 were the period of ascendancy for *zisha* ceramics. In 1918, the Jiangsu Provincial Ceramics Factory was established specially for the production of *zisha*. In the same year, the Kiln Industry of Jiangsu State Yixing Vocational School, which had been established in 1915, was moved from Yixing to Shushan. The Yixing *zisha* industry came to realize unprecedented prosperity in 1932. The number of craftspeople within this industry swelled to more than 600, and the production value of *zisha* accounted for 15% of the entire ceramics industry of Yixing.

In 1937, however, with the Japanese invasion of China, World War II, and the period of Chinese civil war, the pottery industry was left decimated. It was not until the beginning of the 1950's, after the founding of the People's Republic of China, that Yixing *zisha* indus-

try was revived and experienced growth once again.

Many of the craftsmen who had been scattered by the winds of history were found again, and their ranks reorganized. New equipment replaced damaged or destroyed facilities. Furthermore, many literate young people were now recruited to study the ceramics industry, to either apprentice with old masters or to attend colleges and universities for training in ceramics industry management.

The openness and scope of social reform brought another period of unprecedented prosperity for the ceramics industry in general and for *zisha* ware in particular. There emerged a group of famous masters, whose artistic skill has inspired generations of future artists.

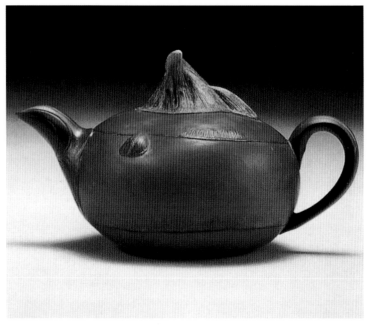

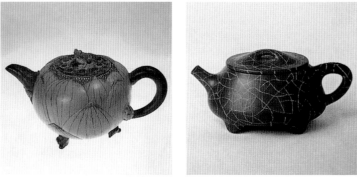

Top: Teapot in the shape of water chestnut made by Jiang Rong.
Bottom left: Teapot in the pattern of lotus flowers made by Jiang Rong.
Bottom right: Teapot with crack patterns made by Xu Hantang.

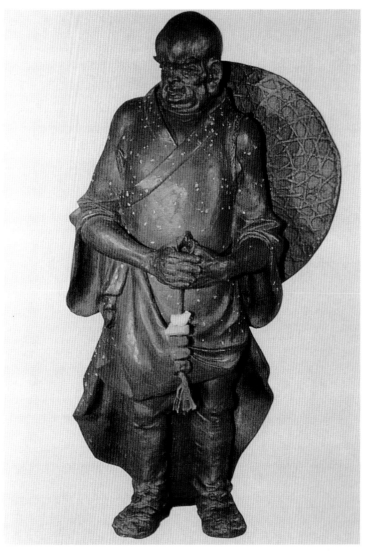

Purple claysculpture of a monk made by Xu Xiutang.

6. Masters of Yixing Ware

Seven famous craftsmen born at the end of the 19th century or at the beginning of the 20th century have made tremendous contributions to the prosperity of *zisha* ceramics. They have designed and made not only many *zisha* ceramic pieces, but also imparted their skills to later generations, thereby assuring the continued cultivation of *zisha* artisans.

Ren Ganting (1889-1968)

Ren, also known as Foushuo, was a famous craftsman of *zisha* whose skill emphasized carving and painting. He was born to a literary family, but the financial fortunes of his family declined and he began to learn carving and painting skills by following craftsman Lu Lanfang at the age of fifteen. When he finished serving his apprenticeship, he made a living by carving and painting in the Wu Desheng Pottery Store in Yixing. His endeavors made him into a master *zisha* painter and craftsman. Ren's work demonstrated a traditional style with many folk art influences. He could also write regular script, cursive, official script, and in the style of seal carving. He painted mainly landscapes, flowers, and birds. Plum, orchid, bamboo and chrysanthemum were also common subjects in his paintings. His style used combinations of realistic and freehand brushwork. The pictures he designed were those of auspicious symbolization. Ren was proficient in knife carving techniques and could inscribe wonderful poems and pictures. He was also ambidextrous when it came to using his hands. Ren was a participant in the National Convention of Industrial Art Representatives as well as the National Labor Heroes Convention.

Pei Shimin (1892-1979)

His original name was Pei Demin. At the age of fourteen, Pei began to learn skills after his brother-in-law, Jiang Zuchen, and as a youth sculpted clay figures. Before the Japanese invasion, he was introduced to Master Mo Wuqi in Shanghai. Besides emulating *zisha*

pieces, Pei also exchanged ideas with Mo on the design of contemporary *zisha* ware. Pei excelled at making curios for the study, such as small containers to hold ink, cups, small plates, stoves, and tripod cauldrons. All of Pei's works were elegant and refined in shape, with the sedate, solid feature and characteristics of copper or bronze ware. *Zisha* ornaments such as crabs and silkworms made by Pei Shimin were vivid and lifelike. Pei was also experienced in the repair of certain *zisha* antiques, with an exceptional ability to choose clay compounds. Pei used to make lids for Gongchun's "gall teapot," and made trays to accompany Xiang Shengsi's "Big Peach Cup," thereby earning the reputation of "the second Chen Mingyuan."

Wu Yungen (1892-1969)

Wu was the senior apprentice of Zhu Kexin. He had also learned skills after *zisha* master Wang Fangrong. When he was young, he used to work as *zisha* craftsman in Shanxin Pingding Ceramics Manufacturing, Nanjing Central University, and Jiangsu Provincial Yixing Pottery School. Wu specialized in the depiction of bamboo.

Wang Yinchun (1897-1977)

Wang was born in Shangyuan Village, Chuanbu. At the age of twelve, he formally acknowledged Jin A'shou as his teacher and began to learn Jin's skills and technique. When Wang was 38 years old, he came to Shanghai to emulate *zisha* works at the stores of various antique merchants, where he got the opportunity to study using the *zisha* pieces of his predecessors. Wang was fond of making geometric shapes as well as organic forms. The style of his works included squares, hexagons, octagons, crabapples, plums, chrysanthemums, etc. The mild color, clear lines, and integral, precisely-fitting lids were highlights of his style.

Zhu Kexin (1904-1986)

Zhu Kexin is one of the great masters of *zisha* art. His original name was Kaichang. Born in Shushan, Yixing, a place teeming with *zisha* activity, he began to learn skills after *zisha* master Wang Fangrong at the age of fourteen. When he finished serving his apprenticeship, his skills had already surpassed those of his teacher. In 1932, he came

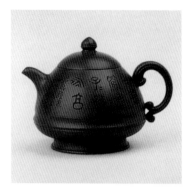
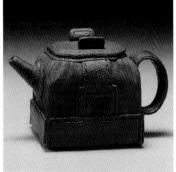
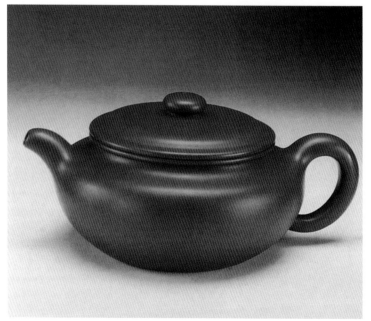

Top left: Teapot in the shape of a stone with inscriptions by Tan Quanhai.
Top right: Teapot in the shape of a leather suitcase made by Xu Xiutang.
Bottom: An imitated ancient teapot of Shao Daheng made by Gu Jingzhou.

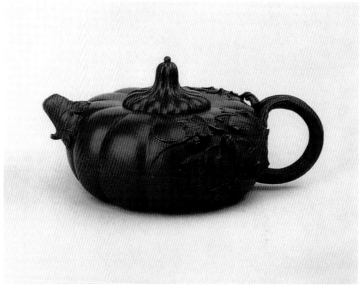

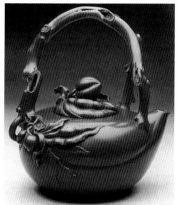 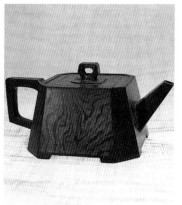

Top: Teapot in the shape of a pumpkin made by Wang Yinxian.
Bottom left: "Five generation" teapot made by Wang Yinxian.
Bottom right: Octagonal teapot in the shape of a well-railing made by Lu Yaochen.

to work as craftsman in the branch of the kiln industry of Jiangsu Yixing Vocational School. His large-scale *zisha* work "Tripod Caldron with Dragons in Cloud" won an award at the centennial Chicago Exposition in the United States. In 1954, at the age of fifty, he came to study in the graduate class of folk art and industrial art held by the Southeast branch of the Central Arts Academy. Under the instruction of artists such as Huang Binhong and Pan Tianshou, Zhu's horizons became open and his theories of art and culture were enhanced to a great degree. This firmly set a solid base for the dramatic development of his skills in later years. Over the next thirty years, he designed and crafted numerous groundbreaking new product styles, such as the "longevity teapot," "Spring-coming teapot," "Colorful Butterfly teapot," and the "Round pine, bamboo, and plum teapot." The often-imitated "Big Peach Cup" of Xiang Shengsi reached a new level of realism. The style of Zhu Kexin was plain, simple, solemn, and graceful. Zhu looked to daily life to find his subject matter. His skills were all-round. Zhu served as a member of the China Artist Association, and held the post of honorary director of the China Pottery Art Association.

Gu Jingzhou (1915-1996)

Gu Jingzhou was honored as a "Great Master of Teapot Art." He was born in Shangyuan village, Chuanshang, Yixing. He was one of the most accomplished *zisha* artists, earning the title of "master of Chinese industrial art." His skills were recognized when he was 20. In the 1930's, he was employed to work for Lang Yushu, an antique merchant in Shanghai. Imitating genuine antiques gave him an opportunity to study many outstanding pieces of *zisha* ware.

Gu had undertaken a great deal of research on the artistic style of *zisha* ware, and authored many original essays on its history. Some of the best examples of Gu's work are the Teapot of Auspicious Clouds, Han Square Teapot, and Snowflake Teapot. He also collaborated with artists Jiang Hanting, Wu Hufan, Yaming, and Han Meilin. Gu's work has won numerous awards and his pieces are highly sought after by collectors.

Teapot with ringed lid
made by Bao Zhiqiang.

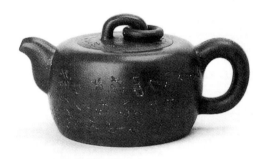

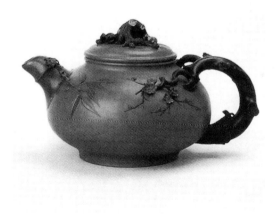

Round Teapot with the patterns of pine,
bamboo and plum tree made by He Daohong.

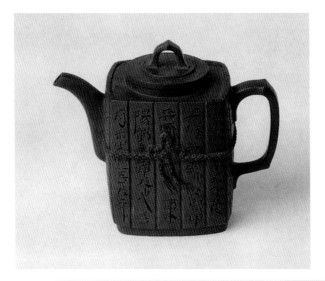

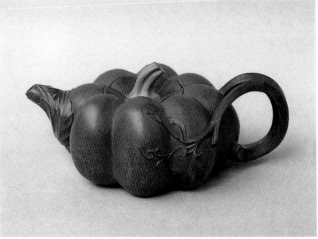

Top: Teapot in the shape of inscribed bamboo-strips made jointly by Li Changhong, Shen Juhua and Shen Hansheng.
Bottom: Pumpkin shaped teapot made by Xu Chengquan.

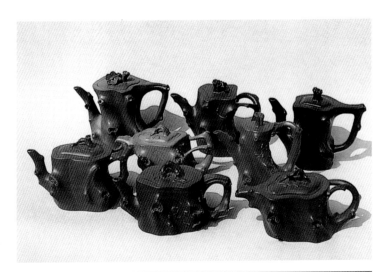

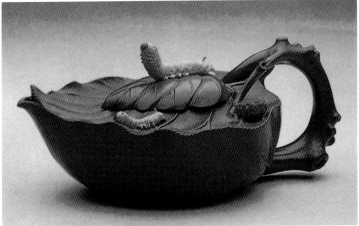

Top: Eight teapots in different shapes of plum-tree trunks made by Xu Chengquan.
Bottom: Teapot with a silkworm on mulberry leave made by Wu Zhen and Xie Manlun.

Jiang Rong (1919-)

She was originally named Jiang Linfeng. Jiang was born to a *zisha* craftsman's family in Yixing, Jiangsu in 1919. At eleven, she began to learn the craft of making *zisha* ware after her father. When she was twenty-one years old, she came to Shanghai and continued to learn with her uncle Jiang Yanting. Jiang Yanting was a notable *zisha* craftsman at that time and had imitated *zisha* antiques for antique merchants for years. In her four years in Shanghai, Jiang Rong had learned not only the many excellent skills and techniques of her uncle, but also studied many works done by famous *zisha* masters of the Ming and Qing dynasties. Jiang's technique and mastery of the art improved by leaps and bounds. She excelled at the craft of teapot making, and her work soon attained the status of artistic pieces, though they still retained their utility and function, including the lotus flower teapot, water chestnut teapot, and lotus wine set. Today, Jiang Rong is considered a master craftswoman.

7. Advanced Industrial Artists

\mathcal{F}ollowing the undisputed masters of *zisha* ware is the "next generation" of craftspeople who hold the title of Advanced Industrial Artist. These individuals continued to hone their artistic skills while at the same time contributing to the widespread appeal of *zisha* ware. In recent years, *zisha* ware has enjoyed a major revival, both domestically and abroad. The worldwide consumption of tea has gained much popularity. Here are some of the major individuals who enabled *zisha* culture to grow and prosper.

Xu Hantang (1933-)
Xu was born into a *zisha* craftsman's family in 1933. Xu learned skills after Gu Jingzhou in the early 1950's. He studied and worked in the research institute of Zisha Industrial Art Manufacturing. In 1975, he came to study in the Jiangsu ceramics art training class of the Central Industrial Art Academy.

Xu Xiutang (1937-)
Xu Xiutang is the younger brother of Xu Hantang. He used to study clay sculpture in the Clay Figurine Zhang workshop of the Central Arts Academy. Later, he devoted himself completely to *zisha* sculpture. His work has earned many awards. He is now a member of the China Artist Association, and Director of China Ceramics Arts Association.

Tan Quanhai (1937-)
Also known as Shiquan, Tan was born in Yixing. In 1958, he learned *zisha* carving and painting techniques after Ren Ganting. In 1975, Tan studied ceramic art at the Central Industrial Art Academy. In 1987, he completed calligraphy-training courses at the Henan Calligraphy Training College.

Lu Raochen (1940-)
In 1958, Lu began to work in the Yixing Zisha Industrial Art

Teapot in the shape of a bamboo
trunk made by Zhou Guizhen.

Teapot in the shape of a sheep
made by Bao Zhongmei and
Shi Xiuchun.

A vase with 100 Chinese longevity characters made by Gu Shaopei.

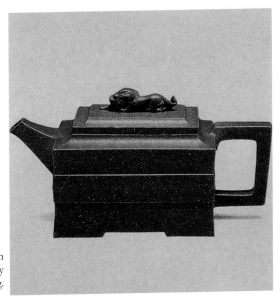

Teapot with a lion shaped lid made by Pan Chiping.

Manufacturing and learned his skills after Wu Yungen. In the 1960s, he was responsible for the training of numerous potters.

Wang Yinxian (1943-)

Also known as Zhaoyang, Wang Yinxian was born in Yixing. In 1956, she came to work in the Yixing Zisha Industrial Art Manufacturing and learned skills after Wu Yungen, Zhu Kexin, Pei Shimin, and Jiang Rong. She had mastered the skills of making teapots with naturally realistic methods. In 1975, she came to study ceramics in the Central Industrial Art Academy.

He Daohong (1943-)

In 1958, he attended the Yixing Zisha Preparatory School and later transferred to Yixing Zisha Manufacturing, where he learned skills after Wang Yinchun and Pei Shimin. In 1975, he studied ceramics in the Central Industrial Art Academy.

Bao Zhiqiang (1946-)

In 1959, Bao came to work at Yixing Zisha Industrial Art Manufacturing and learned *zisha* carving and painting skills after Zhu Gexun and Fan Zelin. Later, he received instruction from Ren Ganting. In 1975, he studied ceramics in the Central Industrial Art Academy, and he also finished the three-year course of China Calligraphy and Painting Training College.

8. The Eight Industrial Art Celebrities of Jiangsu Province

Li Canghong (1937-)

Li was born in Yixing. In 1955, he came to work at Yixing Zisha Industrial Art Manufacturing and learned skills after Gu Jingzhou. Since 1959 he has managed the administration of the factory.

Xu Chengquan (1939-)

Born in Yixhing, she came to work in Yixing Zisha Industrial Art Manufacturing and learned skills after Zhu Kexin in 1955. From 1958 she was responsible for the training of new apprentices. Xu is renowned for sculptures with themes of bamboo and plum. Her work has won numerous awards at the provincial level. In 1985, she transferred to work in Nanjing Art College. In recent years, she had held exhibitions together with her husband Pa Chunfang in Singapore, Taiwan, and the United States.

Wu Zhen (1941-)

In 1958, Wu attended Nanjing Art College. In 1961, he worked at Yixing Zisha Industrial Art Manufacturing and learned skills after Wu Yungen and Zhu Kexin. At the end of the 1970's, he was mainly responsible for administration work. He had worked as the factory director of Yixing Arts and Ceramics Factory for many years. In his spare time he often cooperated with his wife, Xie Manlun, to make *zisha* ware.

Xie Manlun (1942-)

Also known as Xie Maomao. In 1958, she came to work at Yixing Zisha Industrial Art Manufacturing and learned skills after Zhu Kexin and Fan Zhenggen. Her works display a profound skill in depicting bamboo as well as wood.

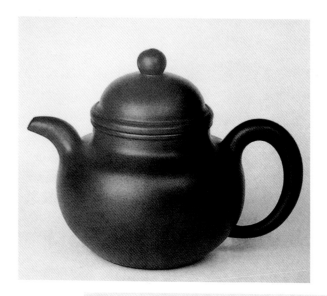

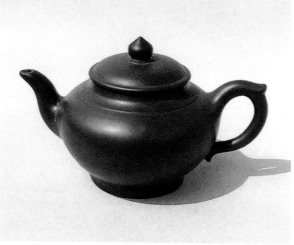

Top: Teapot in ball shape made by Cheng Shouzhen.
Bottom: Teapot with a cute shape made by Xu Chenquan.

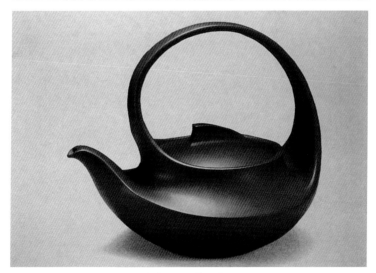

Top: Spring-water teapot made by Pan Chunfang.
Bottom: Teapot with elegant curves made by Wang Yinxian and Zhang Shouzhi.

Zhou Guizhen (1943-)

In 1957, she came to study at Yixing Zisha Preparatory School. In 1958, she worked at Yixing Zisha Industrial Art Manufacturing and learned skills after Wang Yinchun and Gu Jingzhou. She used to cooperate with her husband Gao Haigeng in making *zisha* ware, and together their works have won numerous awards. Zhou's teapots are in the form of geometric shapes executed with fluid, precise lines and demonstrating meticulous skills.

Bao Zhongmei (1944-)

In 1959, Bao came to work at Yixing Zisha Industrial Art Manufacturing and learned the skills of *zisha* carving and painting after Ren Ganting. In the 1970's, Bao began to study new decorative crafts of *zisha*. After the 1980s, he cooperated with his wife, Shi Xiuchun, and invented the mosaic of golden and silver lines on the surface of *zisha* ware.

Gu Shaopei (1945-)

In 1957, Gu came to study in Yixing Zisha Preparatory School. In the next year, he came to work at Yixing Zisha Industrial Art Manufacturing and learned the skills of making *zisha* bottles and vases after Chen Fuyuan. Gao's work includes many categories. He is especially skilled in making tea sets, bottles, and basins, and has won many awards home and abroad.

Pan Chiping (1945-)

Like Gu Shaopei, Pan Chiping studied at Yixing Zisha Preparatory School and worked at Yixing Zisha Industrial Art Manufacturing, learning the skills after Chen Fuyuan. Since 1964, Pan began to design *zisha* pieces independently. After 1981, he began to make teapots under the instruction of Gu Jingzhou.

9. Characteristics of Purple Clay

*Z*isha, or purple clay, is a resource richly endowed by nature. It is concentrated mainly in the region of Yellow Dragon Hill in Dingshu Town, Yixing City and mingled with argil (white clay) of the nearby Jiani mine. After excavation, the clay must be selected and processed by hand. This is the reason why purple clay was also called "clay from clay." Unprocessed *zisha* resembles a block with a flake-like structure. After being stored in the open air, it can decompose into grains approximately the size of soy beans. Grinded by machines into the required fineness, and tempered with water, the clay becomes "mature clay." Craftsman use this kind of "mature clay" to make all manner of ceramic pieces. Some of the unique features common to *zisha* include:

- *Zisha* has near-perfect plasticity in that it can be used to make different articles in different sizes and shapes. Its cohesion force is strong, yet is not sticky when worked using the hands or tools.

- The shrinkage force of *zisha* is small. It will shrink about 10 percent from molding to firing. The temperature of firing varies, and the strain rate is low. This enables the precise fitting of closely matched pieces, such as lids. Shapes and outlines can be distinct and sharp.

- There exists an appropriate quantity of ferric oxide and many other micro-metallic elements among components of purple clay, so the color of *zisha* ware is plain and graceful. The famous artist Gao Zhuang once said: "I love purple clay for it has no color of glaze, just like that you can see one's mind directly. One doesn't rely on the appearance to show his nobility, and only that which is true nature is most valuable and pleasing. "

There are three kinds of *zisha* clay: purple clay, red clay, and green clay. Purple clay is the principle clay. Each kind of clay can be made into pottery on its own, and also can be mixed with other kinds of clay to produce different colored ware.

Generally, purple clay turns red-brown or dark-brown after firing. In order to pursue a color effect, craftsmen usually add iron or

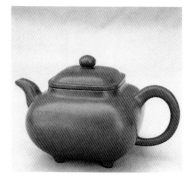

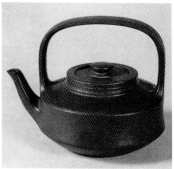

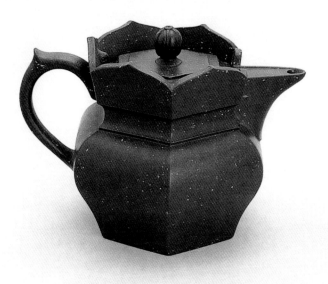

Top left: Stove Teapot made by Yu Guoliang.
Top right: Teapot with a large handle made by Gao Zhuang and Gu Jingzhou.
Bottom: Monk Cap Teapot, an imitation of Dabin's work, made by Gu
Jingzhou.

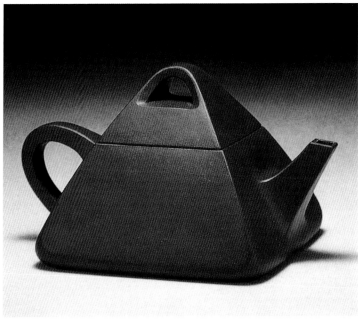

Pyramid Teapot made by Pan Chunfang.

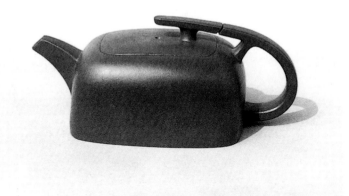

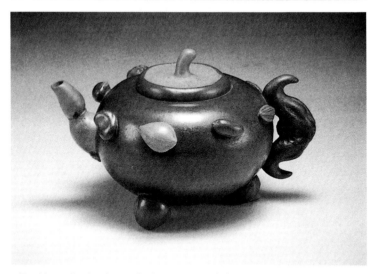

Top: Teapot in the shape of a lying tiger made by Pan Chunfang.
Bottom: Teapot decorated with different fruits.

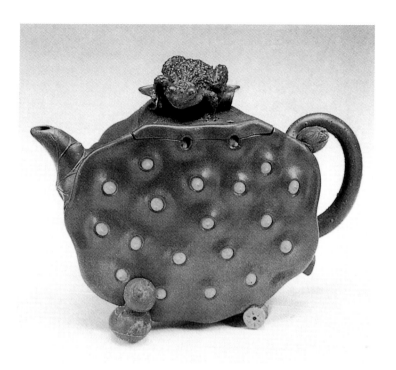

Teapot in the shapes of frog and lotus seeds made by Gao Haigeng.

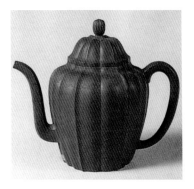
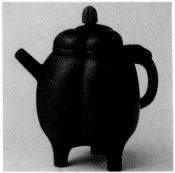
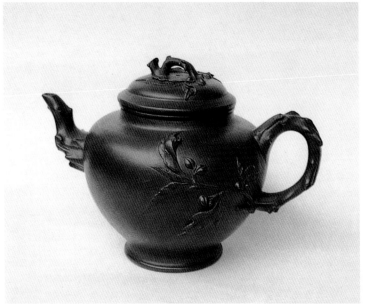

Top left: Teapot in the shape of water-chestnut flower made in the Ming Dynasty.
Top right: Teapot with three pedals and legs made by Xu Youquan in the Ming Dynasty.
Bottom: Teapot of spring scene made by Xu Chengquan.

47

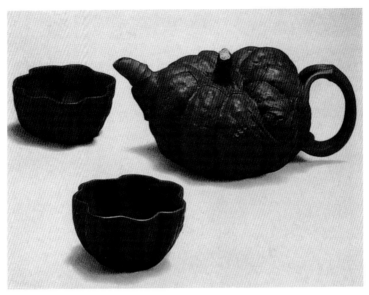

Teaware set in the shape of pumpkin made by Pan Chunfang.

vermillion clay, but these are closely-guarded secrets.

Red clay is produced in the argil "tender clay" mine. It is also sometimes called "Stock Yellow." It shows vermillion after firing. " Tender clay" is a kind of sticky raw material which is indispensable for the making of rough pottery. While the contraction percentage of "tender clay" is high, the contraction percentage of vermillion clay is also much higher than that of purple clay, so vermillion clay is not suitable to make large-sized articles.

Green clay resembles the color of duck egg shell. It shows off-white after firing. Green clay is also produced in the argil Jiani mine. It appears in smaller, rarer quantities than purple clay, and it is often used for cosmetic applications or decoration.

10. Uses and Shapes

*H*istorical records have spoken very favorably of *zisha* ware in the Ming and Qing Dynasties. Noting its excellent utility, Li Yu of Ming Dynasty said, "No material for making teapots is better than clay, and no teapot is better than Yang Mu teapots. Clay teapots are superior to other teapots because they can keep the original fragrance, taste, and color of tea."

Zisha clay is composed of quartz, kaolin, hematite, isinglass and many other minerals. Fired at a temperature of 1100-1180 degrees Celsius, it produces quartz remains, isinglass remains, mullite, hematite, and double pore structure. The double pore structure in particular, is what helps the *zisha* teapot keep the taste, fragrance, and color of the original tea leaves. Moreover, the components of clay can adapt to the stresses aroused by rapid temperature changes. For this reason, *zisha* ware can be used to contain boiled water in winter.

The numerous shapes of *zisha* teapots show the creativity and unique design of *zisha* craftsmen for generations. According to different shape features, we can divide *zisha* teapots into four types: Round, Square, Sculptured, and Veined.

Round ware is made up by curves of different directions and degrees of curvature. Round *zisha* ware is appropriate in proportion and smooth in transition. There are many masters who excelled in crafting round-shaped ware in history, such as Shi Dabin, Hui Mengchen, Shao Daheng, Wu Yungen, and Gu Jingzhou, etc.

Square ware is made up of straight lines with different lengths to form geometric patterns, such as square, hexagon, octagon, etc. The flat surfaces, straight lines, and the clear-cut outline of square ware bring a vigorous interpretation to the teapot. The Monk Cap Teapot, Stove Teapot, and Goblet Teapot are famous works which exemplify this style. Square teapots made by Wang Yinchun were straight and elegant, and the joints of lids and pot openings were precise.

Sculpture ware refers to animals or organic objects, and also includes bas-relief. The artistic shape meets, and in some instances,

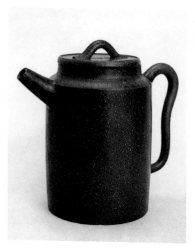

Teapot with a straight body and sand surface.

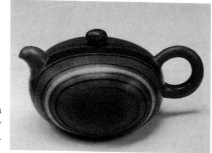

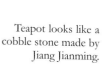

Teapot looks like a cobble stone made by Jiang Jianming.

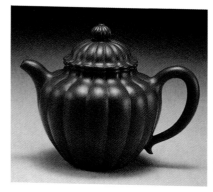

Teapot in the shape of chrysanthemum bud made by Wang Yinchun.

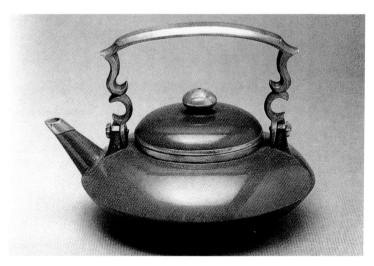

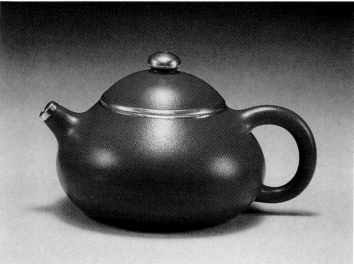

Top: Polished teapot made in the period of late Qing Dynasty or early Republic.
Bottom: Teapot with gold on the mouth and lid.

exceeds, the scope of naturalism. The whole figure of sculpture ware brings visual aesthetic feeling and tactile sensation. It also has rational utility and vivid interest, and of all *zisha* pieces, it is among the most interesting to collectors. The Gall Teapot of Gongchun is the earliest sculpture ware known. Since the beginning of the Qing Dynasty, sculpture ware has gained popularity, and its main proponent was Chen Mingyuan. The sculpture ware of Chen Mingyuan showed unique artistic design, ingenious skill, and wonderful use of natural color. Chen's famous works included Firewood Bundle Friendship Teapot, Pumpkin Teapot, Bamboo Shoot Water Container, Plum Branch Teapot, and Wrapper Teapot, etc. Feng Guilin, living at the end of the Qing Dynasty and the early Republican period, was also a master of sculpture ware. In modern times, Pei Shimin, Zhu Kexin and Jiang Rong have inherited the traditions of sculpture ware in the style of Chen Mingyuan, and imparted those skills to future generations.

Veined ware follows the natural shapes, such as the melon vine, flower petal, or a ripple of water. It integrates solid and abstract shapes into a rich aesthetic experience. The emphasis in design is the profound change of shapes and perceptions. The veins on the lid and on the opening meet consistently and tightly, which produces a beauty of ingenious order. There are many veined pieces in the early period of *zisha* ware. These were due to the extant influence of metal ware, such as copper. Examples of veined ware include the Water Caltrop Teapot by Dong Huan, and Eighteen Chrysanthemum Petals Teapot by Shi Dabin. Li Zhongfang, Xu Youquan and Shen Zice also produced vein ware.

11. Decorative Methods

*A*lthough *zisha* ware is renowned for its simple, plain, and elegant shape, there are also a variety of decoration methods unique to *zisha* ware. By the reign of Emperor Qianlong (r. 1736-1795) of the Qing Dynasty, the development of decorative method had reached its zenith and formed a unique style.

Change of texture

To increase the decorative effect with the texture change of clay roughcast is a traditional method employed by Zisha craftsmen. There are three techniques to make texture change: clay compounding, clay setting, and clay mixing.

In *Collection of Famous Zisha Ware in Yangmu* it is stated, "The color of *zisha* ware from the period of Gongchun to the early period of Shi Dabin was lightly dark, and the clay used was fine earth with silver sand in it. This kind of clay was compounded by pottery grains. The beads on the surface dazzle the eyes." This is the method of clay compounding. Pottery grains are the grains of waste pottery or waste purple clay tiles. Compounding can also be done with colorful purple clay pieces.

Clay setting refers to setting pottery grains or grit from the argil mine onto the clay surface, and then smacking them flat to make the grains set into the clay. By doing so, the decorative effect is made from the color comparison of different kinds of clay.

Clay mixing is a traditional decorative method for Chinese ceramics. It emerged in products of the Changsha and Cizhou Kilns during the Tang and Song dynasties. Purple clay mixing is to make natural textures for wood and stone by mixing clay with different colors.

Many shapes and structures of *zisha* pottery are made by assimilating the features of ware made by copper, jade, bamboo, wood, stone and other materials. So the type curve decoration also becomes a feature of *zisha* pottery. There are many type curves used in the

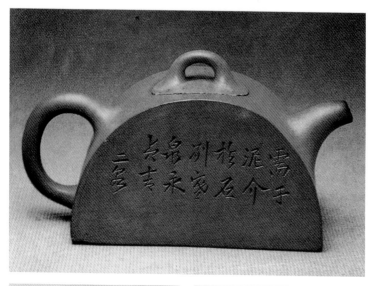

 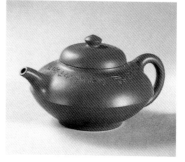

Top: Half Moon Tile Teapot made by Chen Mansheng.
Bottom left: Purple clay teapot in calabash shape made by Chen Mansheng.
Bottom right: Teapot in the shape of two shells made by Chen Mansheng.

55

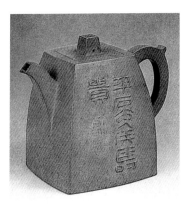 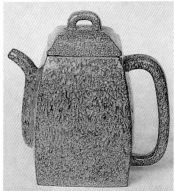 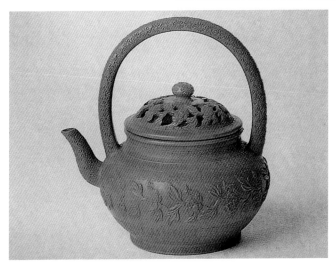

Top left: Square teapot with inscriptions.
Top right: Lujun Han Square Teapot.
Bottom: Relief carved teapot.

shapes of *zisha* pottery. The representatives include rush line, double line (one thick and one thin), cloud rim line, belly line, strap line, sunken-angle line, acute-angle line, knuckle line, etc. The molding craftwork of *zisha* pottery is very religious and all type curves are made with special line ruler made with ox horn, iron or wood. The clear and straight type curves increase the decorative effects.

Line

Usually used on the rims and bottom legs of *zisha* ware. Sometimes it is also used on the shoulder or belly of figures in groups where angles meet.

Double line (one thick and one thin): Used in combination on lid and opening. Double lines are also called civil and military lines. Usually the upper line is thick and the lower thin, and is sometimes called "Sky over the earth."

Cloud line: Used on the transitions of the pot neck and body. It is required to be as "light and thin" as a wisp of cloud.

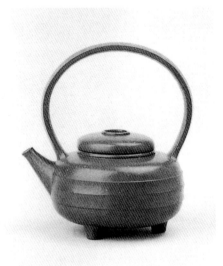

Spring teapot with large handle made by Li Bifang.

Belly line and strap line: Types of lines which are curved and used to decorate the body of *zisha* teapots. The thickness and width of curves can bring different artistic effects. The Cloud Line Teapot is made by joining two pieces of clay. In order to strengthen the joint and cover the joint line, a narrow and thin strap—like a line of cloud—is placed at the joining of the two pieces.

Sunken-angle line: A pair of hyperbolic lines used on the shoulders of *zisha* ware to indicate changes of rhythm.

Acute-angle line, knuckle line: Used on the transition of two faces of square ware.

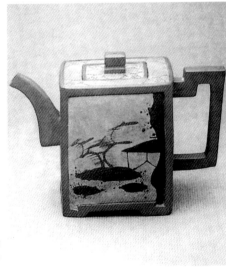

Square clay teapot with
paintings.

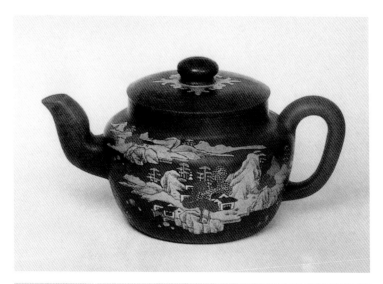

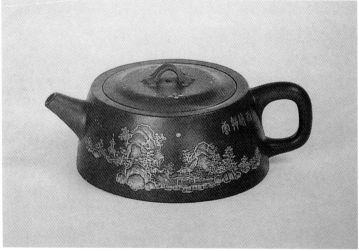

Top: Gaohan Flat Teapot with Colored Glaze.
Bottom: Gilt teapot in the shape of a well railing.

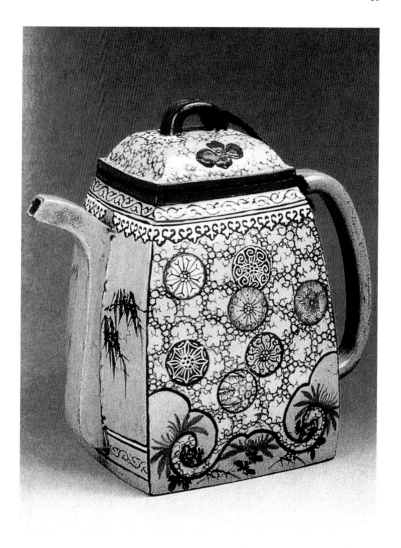

Han Square Teapot with Colored Glaze.

12. Sculpture and Painting

\mathcal{T}he most common examples of *zisha* sculpture decoration are items such as handles, knobs, legs, and teapots, which are crafted into the shapes of flowers, birds, fish, and animals, by a process of careful carving, sculpting, and kneading. Surface features may contain simple decorative elements, often done in bas-relief.

Painting

The painting of *zisha* ware prevailed during the reign of Emperor Qianlong of the Qing Dynasty. Initially, painting took the form of producing a volumetric effect, while multi-colored painting can produce a heightened impression of three-dimensionality.

Painting is applied to the roughcast after it is finished. This requires not only training in calligraphy and painting, but also understanding of roughcast handling.

Printing and pasting

The decoration of printing and pasting includes methods of printing lines, pasting, flower cluster decorations and hollow cut decorations:

The line-printing decoration is used to engrave the decorative diagram on a molding board first, and then join the molding with the clay body. Examples include the Tile Teapot and Square Fret Teapot, by Chen Mansheng.

The pasting diagram decoration can produce an effect with rigorous structure and meticulous diagrams. In history, this method is mainly used in imitating bronze style ware. The common diagrams include diagram of Ruyi cloud, diagram of banana leaf, diagram of cicada, diagram of dragon-like beast, diagram of dragon and phoenix, and diagram of water ripple.

Glaze

Decoration using colored glazes is another decorative style de-

veloped on the basis of traditional painting, by assimilating the craftwork of enamel and powder used in the porcelain made in the vicinity of Jingde. The decoration of *zisha* colored glaze is often used when painting flowers, landscapes, and opera figures with application of pigment on the surface of finished *zisha* ware. The piece is then fired a second time at a temperature of approximately 750-800 degrees Celsius.

Decoration by painting in gold belongs to the same category of colored glaze. In order to paint in gold on the roughcast of *zisha*, a layer of undercoat, or primer, is painted on the surface. The piece is then fired for a second time in a temperature of 750-800 degrees Celsius. After cooling, gold paint is applied directly on the glaze and the piece is fired for a third time, this time at a much lower temperature. Because of the additionally complex working procedures and relatively high cost, there are few *zisha* pieces which display gold painting decorations. Another colored glaze, known as Lujun, was mass-produced toward the end of the Qing Dynasty and the beginning of the Republican period. Some examples include the Lujun Han Square Teapot, Gaohan Flat Teapot with Colored Glaze, Han Square Teapot with Colored Glaze, Hexagonal Teapot Painted in Gold, Qianlong Square Teapot Painted in Gold, and Guoyuan Teapot with Colored Glaze.

Tessellation

Tessellation (or mosaic) of *zisha* ware is formed by assimilating a filigree of copper and or by using mother-of-pearl inlay on rosewood lacquer. The method of tessellation was first introduced to the *zisha* industry by Suzhou rosewood craftsman Lu Hansheng, who fled to Yixing during the War of Resistance against Japan in the late 1930s - early 1940s. Lu instructed the craftsman of Yixing on how to craft filigree on rosewood. However, this type of craft work was not developed further due to the war. It was revived again only during the early 1970's.

There is another kind of tessellation made by processing colored clay. This method is a traditional embellishment technique used in Jianshui of Yunnan and Qingzhou of Guangxi. In recent years, the technique was adapted to be used in the decoration of *zisha* ware.

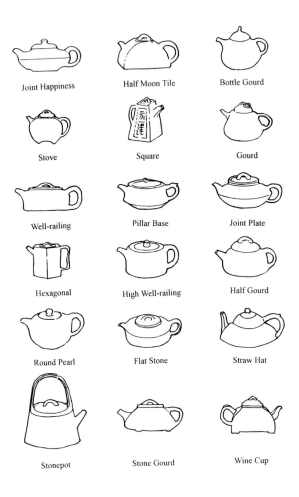

Joint Happiness	Half Moon Tile	Bottle Gourd
Stove	Square	Gourd
Well-railing	Pillar Base	Joint Plate
Hexagonal	High Well-railing	Half Gourd
Round Pearl	Flat Stone	Straw Hat
Stonepot	Stone Gourd	Wine Cup

Teapots of 18 different styles made by Chen Mansheng.

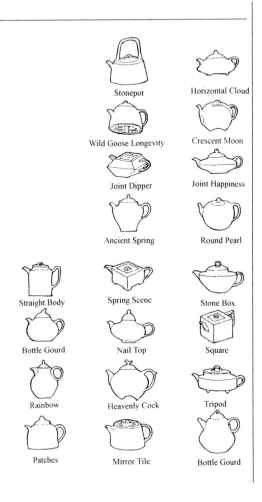

Stonepot

Horizontal Cloud

Wild Goose Longevity

Crescent Moon

Joint Dipper

Joint Happiness

Ancient Spring

Round Pearl

Straight Body

Spring Scene

Stone Box

Bottle Gourd

Nail Top

Square

Rainbow

Heavenly Cock

Tripod

Patches

Mirror Tile

Bottle Gourd

Teapots of 20 different styles made by Chen Mansheng.

Inscriptions on the teapots made by Chen Mansheng.

Some representative examples include Splendid Tea Set with Inlaid Gold by Bao Zhongmei and Shi Xiuchun; Pearl and Jade Teapot by Wu Guangrong and Xu Yanchun, and the Qianlong Purple Clay Carved Lacquer Teapot.

Carving

The history of *zisha* carving and painting decoration evolved from the simple inscription of the potter's name on the pottery piece, and first emerged during the Yuan Dynasty. During the reign of Emperor Wanli of the Ming Dynasty, variations of inscriptions on *zisha* ware became popular. For example, on the bottom of the hexagonal teapot made by Shi Dabin were engraved two lines in regular script which read "Made by Shi Dabin in the Wanli Time." On the bottom of another teapot was engraved, "One cup of tea can bring inspiration of composing poem. Made by Shi Dabin."

From these two works we can trace the development of carving and painting decoration and, in particular, the influence of literati during the Ming Dynasty. The technique developed from a simple inscription of the potter's name into a highly cultivated appreciation of literature, calligraphy and seal carving. During the era of the Ming and Qing dynasties (1368-1911), there were more than one hundred artists and scholars participating in the creation and development of *zisha* pottery. The noted calligrapher Zheng Banqiao and Wu Cangshuo both used to write poems on *zisha* teapots. During the reign of Emperor Daoguang of the Qing Dynasty, the inscriptions done by calligraphist Cheng Hongshou, one of the "Eight masters of Xileng of Hangzhou," had made great contributions to the prosperity of *zisha* carving and painting decoration as a refined art.

Cheng Hongshou, whose ancestral home was located in Qiantang, Zhejiang, lived during the Qianlong-Daoguang era of the Qing Dynasty (c. 1768-1830). Cheng's knowledge of antiques was well appreciated. Later he worked as an official of Huai'an, Jiangsu. Cheng Hongshou was fond of calligraphy, and was especially keen on stone inscriptions and rubbings taken from stone inscriptions. His style of calligraphy was known as Ba Fen Shu, which was plain but especially elegant. His seal cutting technique followed the traditional style of the Qin and Han dynasties. Cheng also loved painting landscapes, but was also skilled at painting flowers, orchids and bamboo.

66

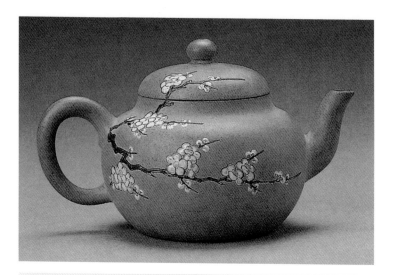

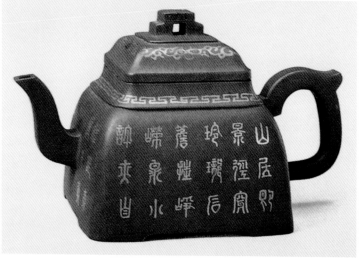

Top: Guoyuan Teapot with Colored Glaze.
Bottom: Qianlong Square Teapot Painted in Gold.

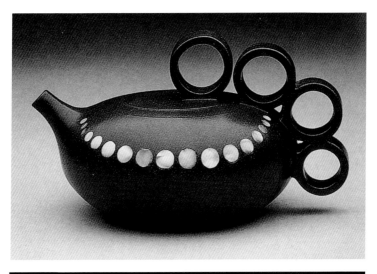

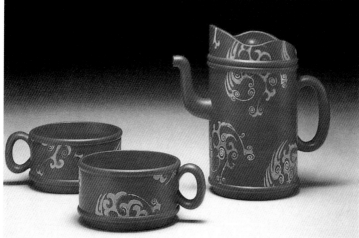

Top: Teapot with the appliqué of pearl shells made by Wu Guangrong and Xu Yanchun.
Bottom: A set of teaware with the appliqué of gold made by Bao Zongmei and Shi Xiuchun

 Zisha had experienced two divergent schools in the form of an independent craftwork system in the middle of Ming Dynasty to the middle of Qing Dynasty. The first school appeared in the Wanli reign in the middle of Ming Dynasty. A group of famous craftsmen appeared in that time, like Shi Dabin and Xu Youquan. During this period, *zisha* teapots attracted many elements and characteristics from copper and stannum (silver or lead alloy) ware as well as Ming-style furniture, which showed a strong influence on later veined ware. The second school came at the ending of Ming Dynasty and the beginning of Qing Dynasty. The creativity of master craftsmen, such as Chen Zhongmei and Chen Mingyuan, brought tremendous advances in the refinement of *zisha* ware. During the Kangxi, Yongzheng, and Qianglong eras of the Qing Dynasty, Zisha still enjoyed tremendous prosperity.

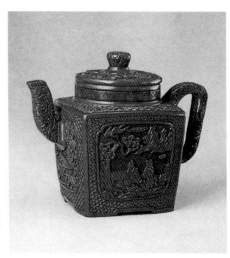

Purple clay teapot with lacquer encasing for Emperor Qianlong.

During the two hundred years from the beginning of Qing Dynasty to the middle of the 19th century, the shapes of *zisha* teapots had gained little in the way of innovation and literati living in that time were dissatisfied with this situation. They believed that the imperial style of decoration on *zisha* teapots had lost its traditional plain and elegant style. Many were eager to reform the appearance of *zisha* ware from an aesthetic perspective. At that time, Chen Mansheng worked as an official of Liyang and Yixing, and had an opportunity to study modern *zisha* production methods. Chen Mansheng also participated in the design work of contemporary zisha pieces. Chen relied on excellent craftsmen to pursue the manufacturing of large numbers of zisha pieces. Judging by the Mansheng teapots left today, we can infer that a harmonious relationship existed in those days between literati and craftsman.

The shapes of Mansheng teapots were simple but demonstrated lasting elegance and a sense of consummate refinement. Most were in geometrical shapes. The influences of these shapes were varied, and most were taken from everyday objects. One category of teapots was influenced by the shapes of bronze and copper pieces from the Han Dynasty. Some examples are "Mirror Tile Teapot," "Stonepot Teapot," and the "Longevity Teapot."

Another category of teapots was one which displayed daily-use utensils like "Bucket Teapot", "Pillar Base Teapot", and "Well-railing Teapot". The third category was one which displayed natural forms, such as the "Melon Teapot," "Calabash Teapot," "Round Pearl Teapot," and "Sky Rooster Teapot." Mansheng designers also employed different textures and clay compounds to enhance the artistic effects according to the teapot's shape. The clay color and texture of Mansheng teapots included: sky blue, vermillion, and pear peel.

Although the shapes of Mansheng teapots came from all kinds of objects, above all they had to be functional, that is, they had to be useful and effective as working teapots that one could also admire as a work of art. No matter the shape, first and foremost the concern was for its effectiveness in steeping tea. The designers followed a rigid set of requirements concerning the volume, height, size, weight, and feel of the teapot.

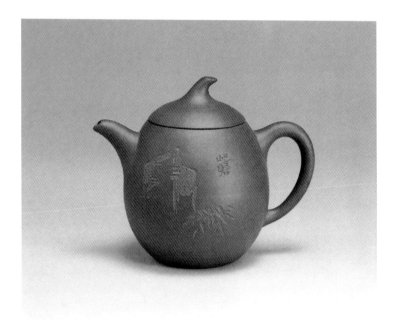

Teapot in the shape of a pear by Zhu Qizhan.

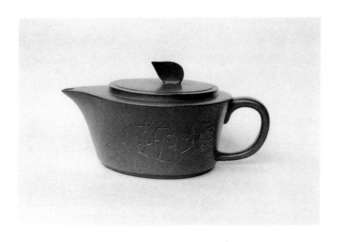

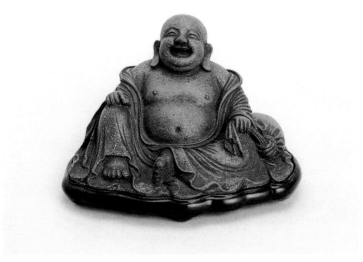

Top: Teapot made by Pan Chunfang and carving with the inscriptions by Zhang Daoyi.
Bottom: Maitreya Buddha made by Shi Dabin.

Although the design of Mansheng teapots placed emphasis on utility, the influence of literati could be found everywhere. This was especially true when examining the overall design of the teapot shape, and the inscription, which showed a strong literary influence. For example, the waning moon is a common phenomenon of nature. Chen Mansheng designed a teapot to describe this shape and inscribed on the surface, "The wane comes after the full moon. I remember this principle and regulate my activities by it." This demonstrates the trait of modesty. Another teapot was also made in the shape of a Han-Dynasty tile, with the inscription: "Not to pursue one hundred percent perfection can make one live long, like drinking from a sweet spring." This adage preached tolerance. All these works showed the ingenious design and life philosophy of literati at that time.

The calligraphy and inscriptions on Mansheng teapots also set fresh examples for later generations. The layout of inscriptions was determined according to the teapot shape. For a taller teapot it was set vertically, while for a lower it was set horizontally. The artistry of wielding the carving knife and the depth of carving also varies according to the texture on the teapot body.

When Chen Mansheng worked in Xizai, Guanjing, he met Yang Pengnian, a skilled teapot craftsman, and found that Yang made spout without a mold. The whole family of Yang was so good at this skill, that they were able to make spouts free-form. Mansheng drew eighteen styles of teapots for them to make.

After Chen Mansheng, there emerged a group of literati keen on *zisha* carving and painting, like Zhai Yingshao, Deng Kui, Zhu Jian, and Zhai Yingshao.

Flower vase carved with 100
Chinese longevity characters
made by Xu Chengquan and
Pan Chunfang.

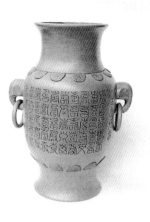

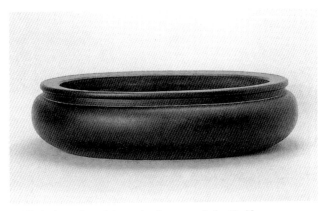

Elliptical pot for miniature landscape made by Xu Youquan.

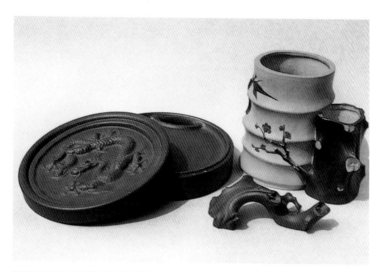

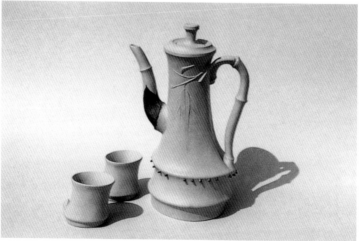

Top: Chinese stationary made by Xu Chengquan and Pan Chunfang.
Bottom: Wineware in the shape of bamboo made by Xu Chengquan.

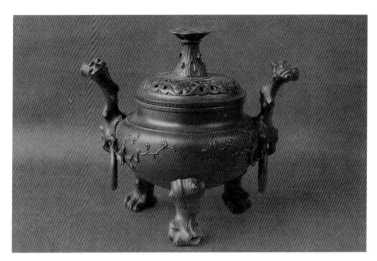

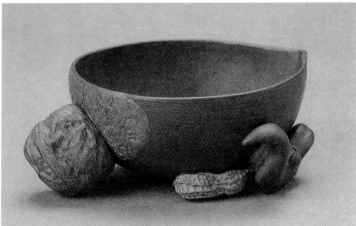

Top: Tripod with plum blossom made by Xu Chengquan.
Bottom: Fruit shaped water container for Chinese calligraphy.

13. Appreciation and Collection of *Zisha* Ceramics

\mathcal{F}or anyone interested in tea, the first thing to learn is what kind of teapot is good. Consider the following six words: shape, clay, fire, craftsmanship, lines, and utility.

Shape. When you observe the teapot from a distance, only those teapots with unique shapes, harmonious bodies, an appropriate physical scale, and an air of individuality come into your eyesight first. With careful observation, you will find that no matter the shape or natural shape, the teapot must be refined. Each component of the teapot, such as the spout, the lid, the handle, and the body, is combined with the others to form an aesthetic and functional whole.

Clay means the quality of teapot material. Purple clay varies due to different methods of mine lodes, mill runs, and processing. Fine purple clay has a mild color, and a plain but elegant bearing. The color is contained inside the clay, and is usually called "liquid color." Teapots made of this kind of clay can shine like jewelry if crafted correctly.

Fire, or firing, refers to the firing process. Only those pieces which are evenly fired and displaying even color free of impurities are considered excellent.

Craftsmanship. The special crafts and skills of making *zisha* teapots were first invented by Shi Dabin on the basis of inheriting the skills of his predecessors. The quality of craft work determines the aesthetic quality and appeal of *zisha* products.

Lines means the decorations on the surface of teapot. There are many kinds of decorative methods on *zisha* teapots. When selecting teapots with inscriptions, first look at the content of the inscription, and then observe the artistry of wielding the carving knife and the artist's calligraphy.

Utility. *Zisha* teapots have experienced centuries of development, but their central purpose remains unchanged. Tea culture is an aesthetic experience, and the *zisha* teapot is perhaps the ultimate integration of function and aesthetics.

Chronological Table of Chinese Dynasties

Five August Emperors	c.30th-21st century B.C.
Xia Dynasty	c.21st-16th century B.C.
Shang Dynasty	c.16th-11th century B.C.
Zhou Dynasty	c.11th century-221 B.C.
Western Zhou Dynasty	c.11th century-771 B.C.
Eastern Zhou Dynasty	770-256 B.C.
Spring and Autumn Period	770-476 B.C.
Warring States Period	475-221 B.C.
Qin Dynasty	221-207 B.C.
Han Dynasty	206 B.C.-A.D. 220
Western Han Dynasty	206 B.C.-A.D. 23
Eastern Han Dynasty	A.D. 25-220
Three Kingdoms Period	220-280
Jin Dynasty	265-420
Western Jin Dynasty	265-316
Eastern Jin Dynasty	317-420
Southern and Northern Dynasties	420-589
Sui Dynasty	581-618
Tang Dynasty	618-907
Five Dynasties	907-960
Song Dynasty	960-1279
Northern Song Dynasty	960-1127
Southern Song Dynasty	1127-1279
Liao Dynasty	916-1125
Kin Dynasty	1115-1234
Yuan Dynasty	1271-1368
Ming Dynasty	1368-1644
Qing Dynasty	1644-1911

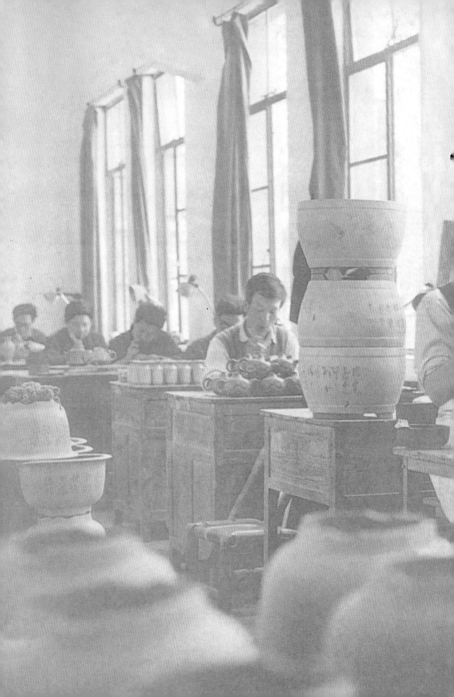